HOW TO DRAW
ANIMALS

Charles Liedl

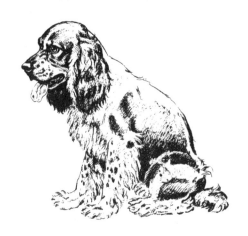

DOVER PUBLICATIONS, INC.
Mineola, New York

Bibliographical Note

This Dover edition, first published in 2007, is an unabridged republication of the work published by Greenberg : Publisher, New York, 1953.

Library of Congress Cataloging-in-Publication Data

Liedl, Charles.
 How to draw animals / Charles Liedl — Dover ed .
 p. cm.
 Originally published: New York : Greenberg, 1953.
 ISBN-13: 978-0-486-45606-5 (pbk.)
 ISBN-10: 0-486-45606-4 (pbk.)
 1. Animals in art. 2. Drawing—Technique. I. Title.

NC780.L47 2007
743.6—dc22

 2006052290

Manufactured in the United States by LSC Communications
45606409 2018
www.doverpublications.com

Contents

Introduction

Contrary to the general belief that animal drawing belongs to the simpler and easier forms of art, there are many difficulties which do not handicap the still-life, landscape, or portrait artist. Nevertheless animals are among the most fascinating of all the artist's subjects. While the time element plays little or no part at all in still-life, animal sketching requires fast thinking and execution. Animals move and change poses frequently — usually when you don't want them to — and many half-finished or just-begun sketches will be the reward of all sincere effort. It is important to know well the anatomy of your subject, for when you start to sketch, you will have very little time for such study. Animals simply will not hold poses very long; some disturbance will usually make them move.

There are many similarities between the body structures of human beings and animals, and even more between those of different animals. Thorough knowledge of one enables the artist to observe modifications in the groups, families, and species. It would be useless to give formulas for measurements of the different parts of the body. They would not hold in foreshortening; different breeds and individuals in the same species show a marked difference in proportion. Most young animals show some analogies to young human bodies. They have rounder skulls and foreheads; the faces are shorter and smaller in proportion to the skulls than are those of the adults. The legs often seem to be out of proportion, as for instance in the fawn, colt, calf, and so forth. The fur and plumage will show a wide variation in thickness, length, and color, according to the seasons. In the winter, animals look more husky than in the summer. The beautiful coloring of birds' plumage during the spring fades to simple gray and brown after the mating season. In most animals the males are better marked, bigger, with shorter heads and necks and stronger legs. Differences in size reach almost unbelievable proportions in many instances — for example, the baboon.

Animals also have similar habits — such as resting more or less in the same positions — that will enable you to finish sketches at a later time. Different species belonging to the same family will reveal certain common characteristics which, if you are familiar with them, can be most helpful in fast sketching.

How To Begin

The Orientals have a golden rule for achieving success in animal art: "Observe much and long and draw quick and little." In the beginning you should draw the subject from the easiest angle and proceed systematically to the more difficult, leaving until last the most challenging and interesting of all — the creature in quick motion, running or flying.

Your sketchbook should be of medium size; a large book tires the hand and arm and is not very practical.

With a few straight, light lines, sketch the general silhouette in geometrical forms, always comparing the height to the length. Then divide with more light, straight lines the different parts of the body — the neck, head, and legs. Similarly divide still further the smaller parts and details. Thus you can minimize the errors in proportion. Then sketch the subject with light lines. Now you may go over it more carefully with a stronger and more definite line, filling in more detail.

If possible, start with animals sleeping or resting so that you'll have more time for observation and study without interruption. Thus you can get acquainted with form, character, and detail — all of which will come in handy when later you have to produce good drawings rapidly. If the animals move or change their position, try to follow them up, changing your position accordingly. When you work in lines, the changes in light will not disturb you very much. If you pick one animal from a group and he moves, just stop and wait; in a little while another animal will usually take its place and resume the same pose. Then you can complete your sketches. If you make sketches from every angle, what you cannot see clearly from one you will be able to observe from another. To simplify your problems in the beginning, you may want to disregard the different marks, spots, and stripes because they confuse the forms. Later on, the distinctive markings, if they are well observed and drawn, will emphasize and accentuate the form and plasticity of your subject.

The better you know the animals, the better drawings you will produce. As soon as you have mastered the anatomy you can concentrate on action, form, and detail.

Since you will not be able to ask the animals to turn the way you want them to, a little noise, whistling, moving the feet, or tapping the fence with a pencil may get them to turn your way. A pose may be reversed by throwing a little food behind the animal to get him to turn around and resume the pose in which you had started to draw him. After the line sketching becomes comparatively easy, you may turn to shading. By outlining the lightest and darkest spots you can give more tone to the full sketch, leaving white paper for the lightest highlights and heavy shading on the darkest spots. The shape and form of the highlights and shadows should be carefully observed. You will note that they follow the muscles and bone structures of the animals.

Skulls of Mountain Lion, Grizzly Bear, and Black Bear

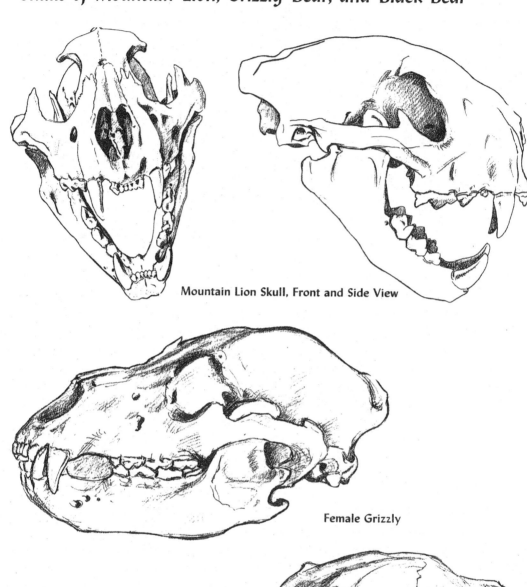

Mountain Lion Skull, Front and Side View

Female Grizzly

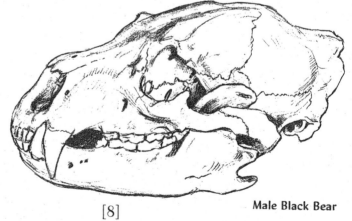

Male Black Bear

Mountain Goat and Sheep, Pronghorn Antelope Horns.

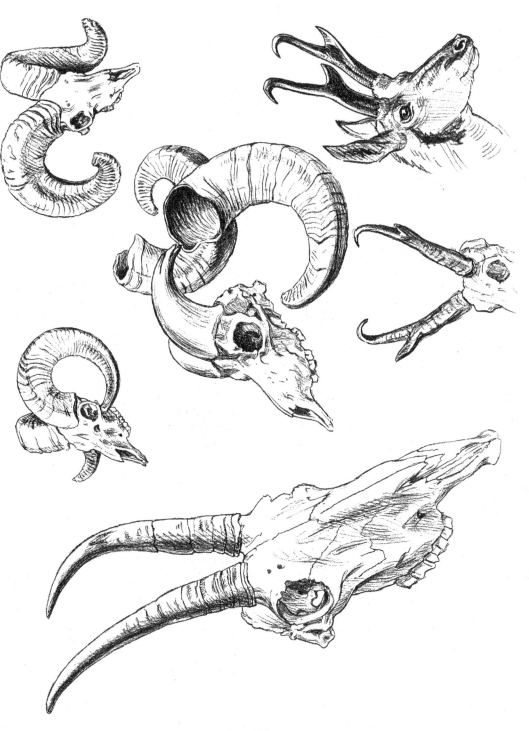

Moose, Elk, Mule Deer, and Caribou Antlers

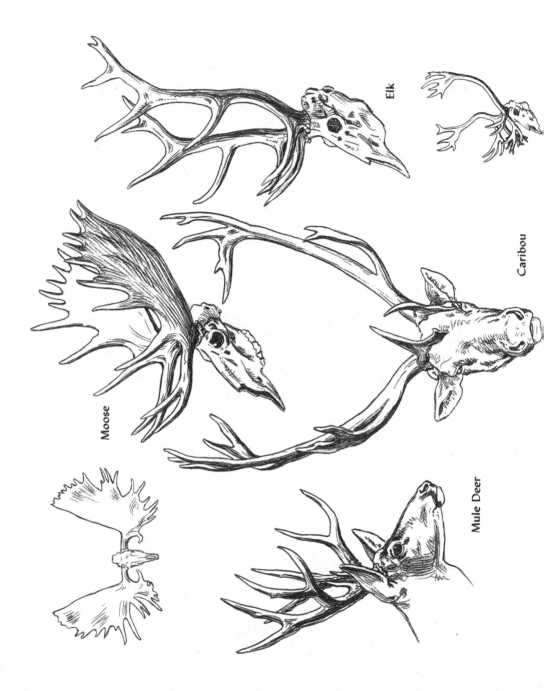

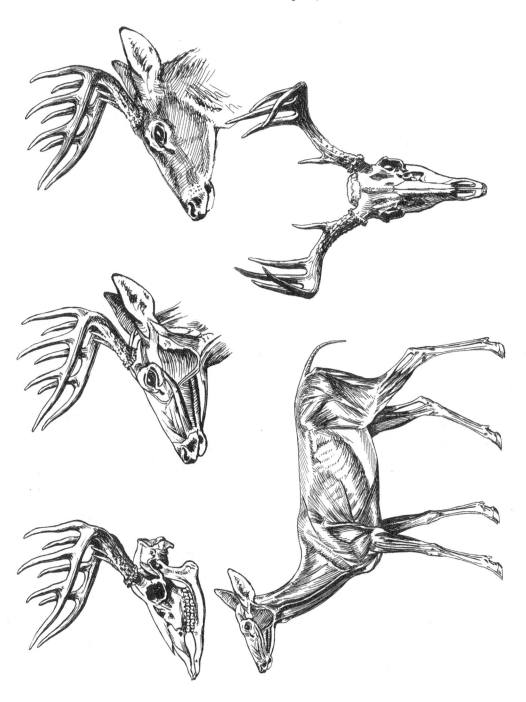

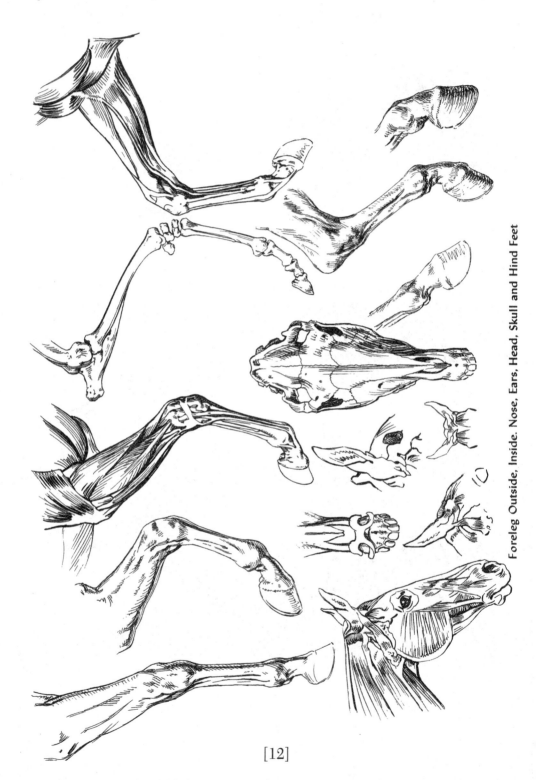

Foreleg Outside, Inside. Nose, Ears, Head, Skull and Hind Feet

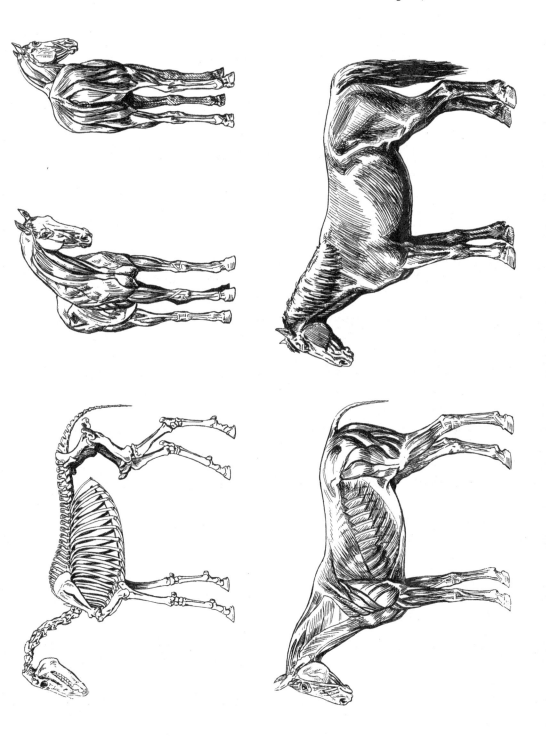

What Media to Use and How to Use Them

While a pencil cannot render the depth of crayon and charcoal, it has the advantage of not smearing so easily and hence your sketches are more likely to preserve their freshness. It is wise to have on hand several well-sharpened pencils. Soft pencils break or wear down quickly, and you don't want to be forced to take time out to sharpen them.

To control the correctness of your sketches, observe carefully the negative forms. The fence, part of the stable, or a tree trunk in relation to the outline of your model will compose some negative shape or form and the errors in your drawing can be corrected. Whatever gives you the most difficulty should be drawn more often and more carefully observed until it ceases to be a problem.

Legs and antlers may give you some difficulty, but if you carefully observe the angles they form, with the body, neck, and head — as well as the relation between the branches of the antlers — you will soon get these appendages "right." Remember that the legs support the body and must balance it firmly. If they are carelessly drawn, they will give a quality of uncertainness to the entire drawing.

Note closely the individual differences in the size, shape, and color of your models. By drawing them carefully you will achieve animal portraiture. You will notice the physical changes induced by their various moods. Erect fur, drawn-back ears, wide-open eyes with pupils shrunk to their minimum are signs of anger or fear. The body will be ready to leap or strike or bite. Recording these phenomena accurately will lend fineness to your drawings.

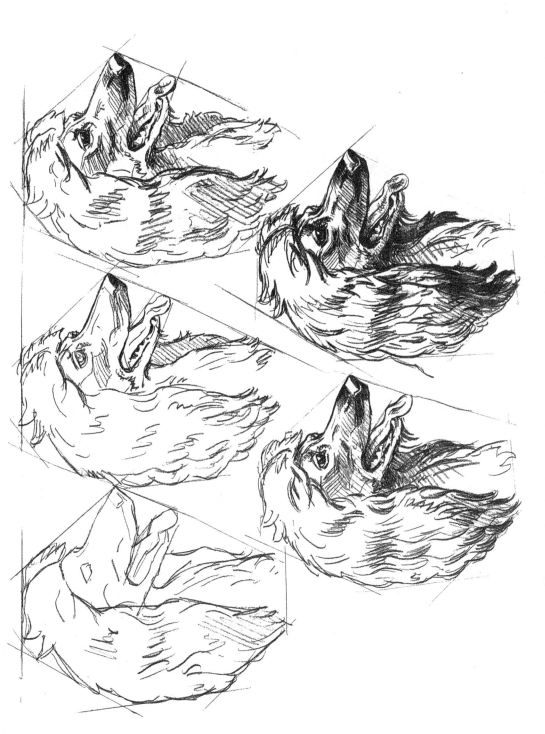

Detail Studies of Game Birds

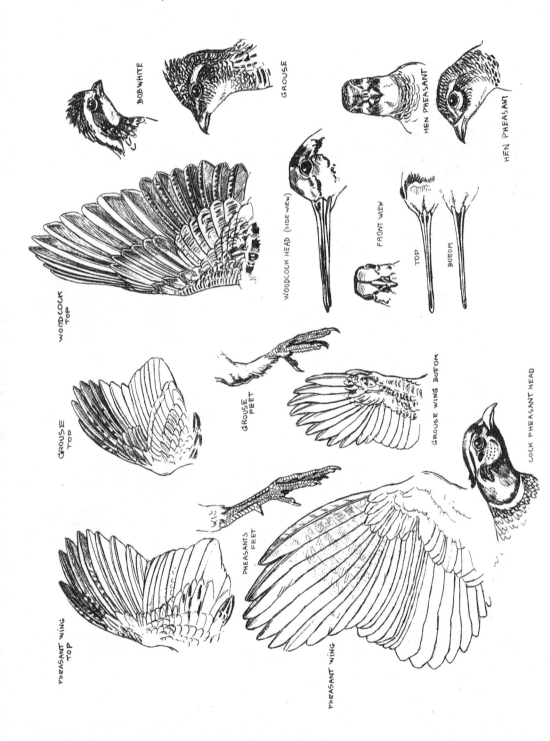

BOB-WHITE

GROUSE

HEN PHEASANT

HEN PHEASANT

WOODCOCK HEAD (SIDE VIEW)

FRONT VIEW

TOP

BOTTOM

WOODCOCK TOP

GROUSE TOP

GROUSE FEET

GROUSE WING BOTTOM

COCK PHEASANT HEAD

PHEASANTS FEET

PHEASANT WING TOP

PHEASANT WING

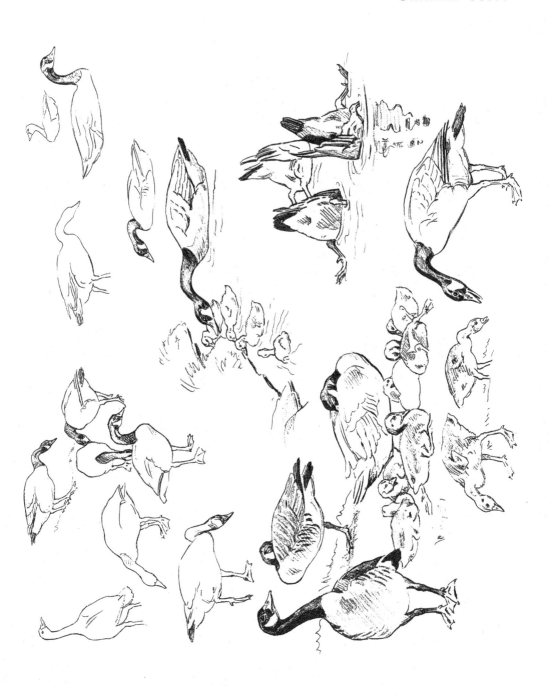

Mallard, Mandarin and Wood Ducks

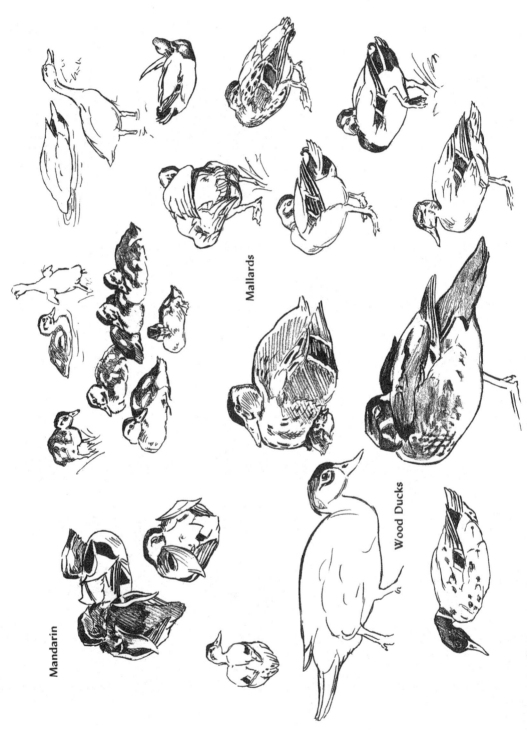

Mallards

Mandarin

Wood Ducks

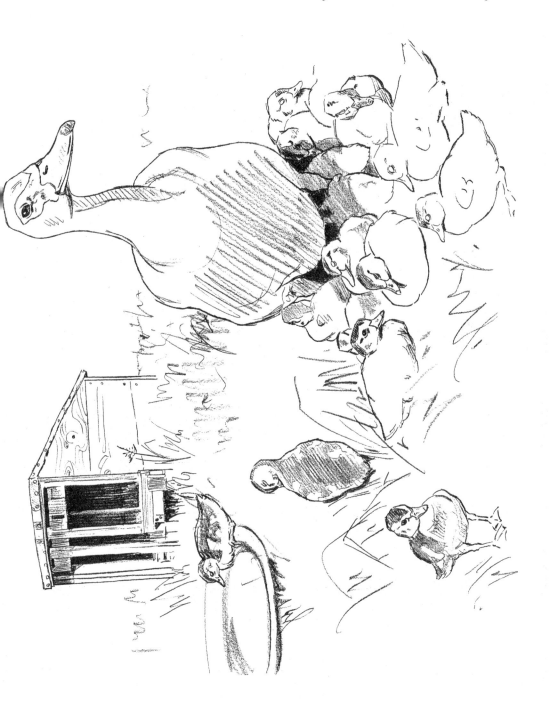

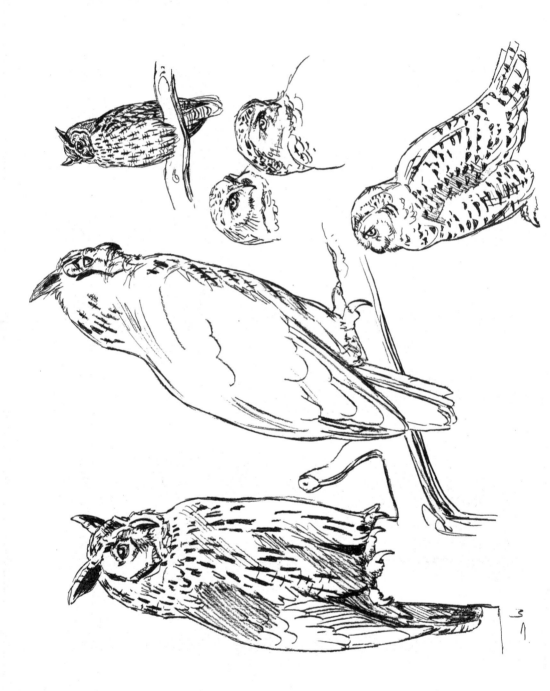

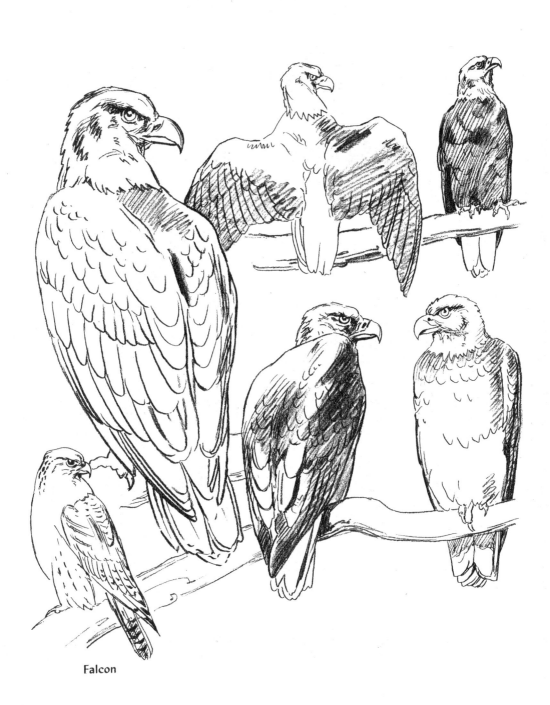

Falcon

Pheasants: Ring-Necked, Kaleege, Silver, and Impeyan

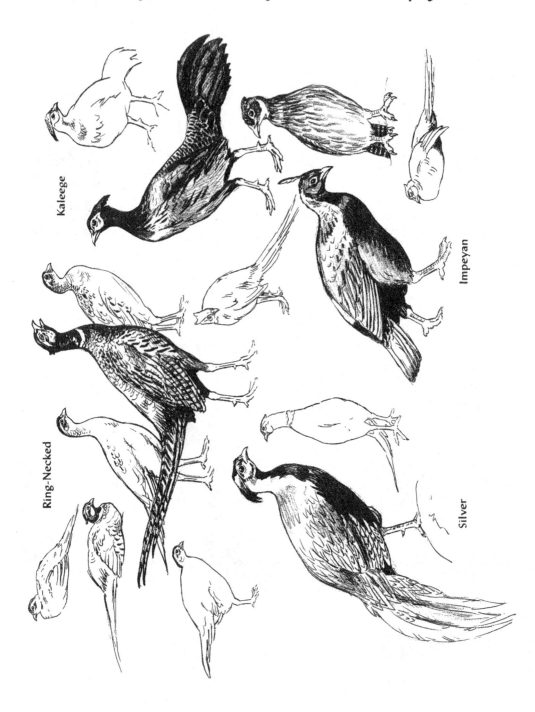

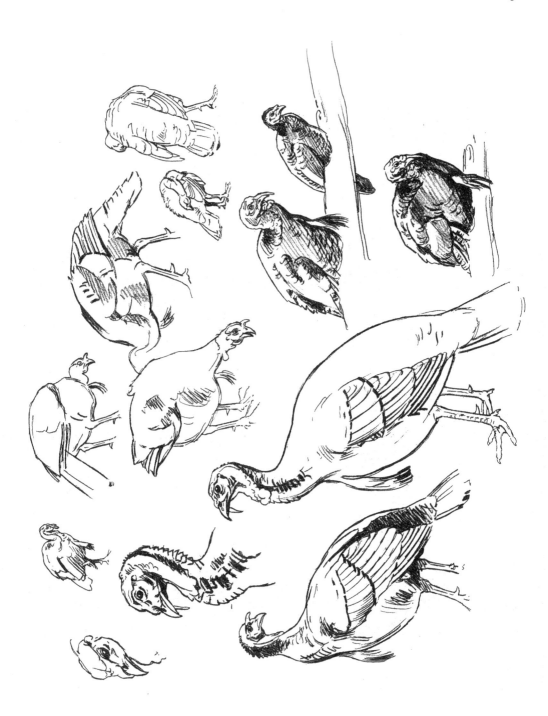

Dogs: Foxhounds

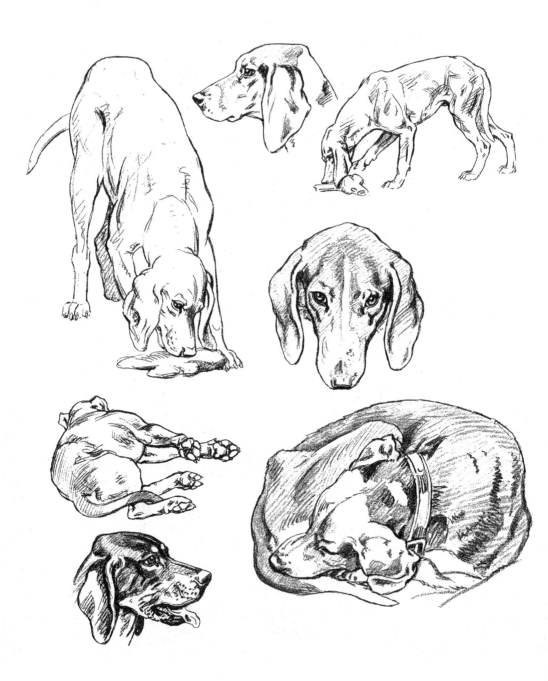

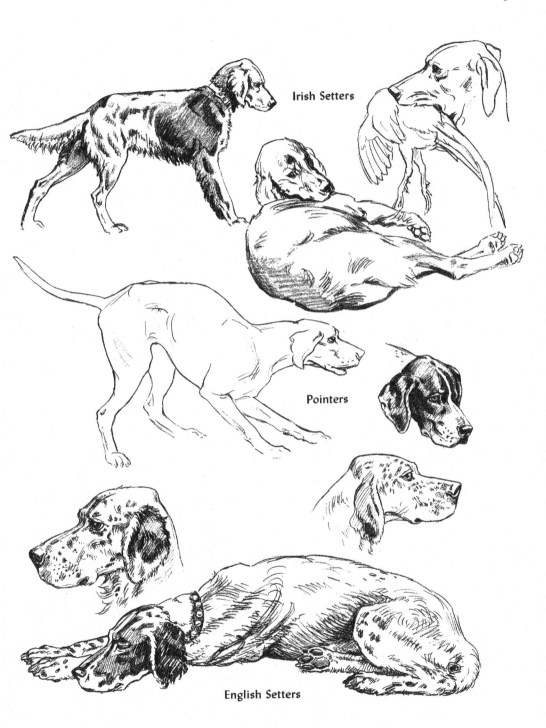

Irish Setters

Pointers

English Setters

Dogs

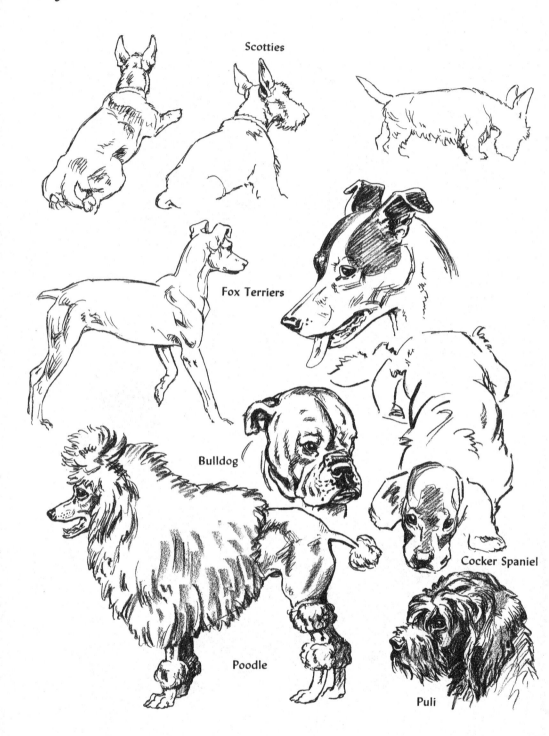

Scotties

Fox Terriers

Bulldog

Poodle

Cocker Spaniel

Puli

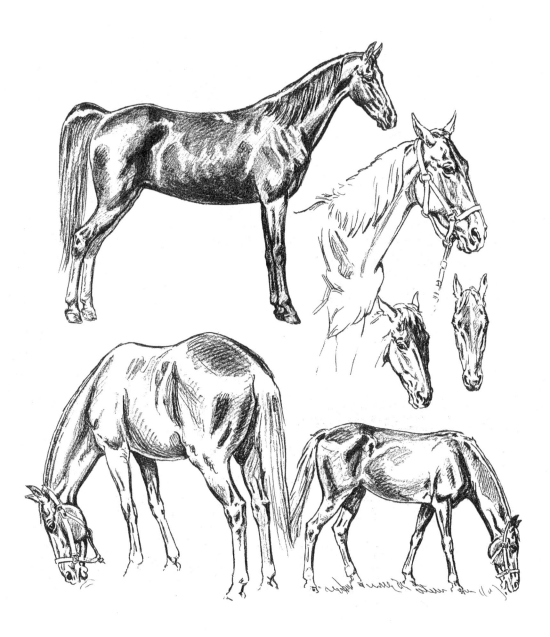

Work Horses

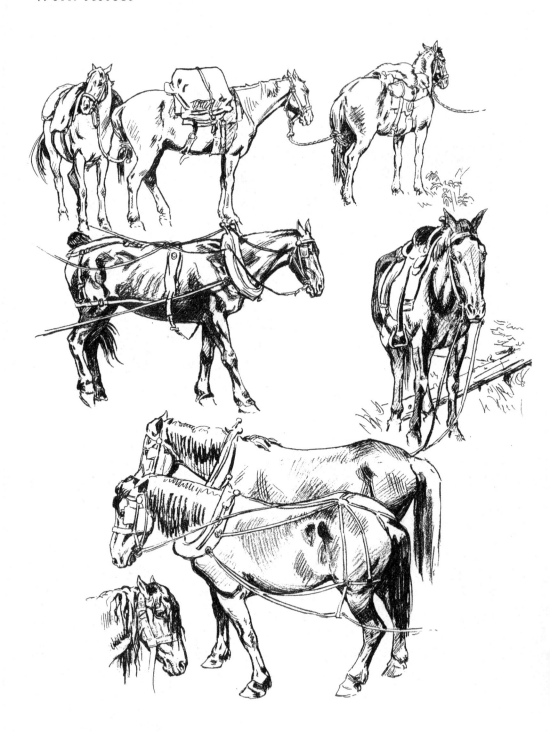

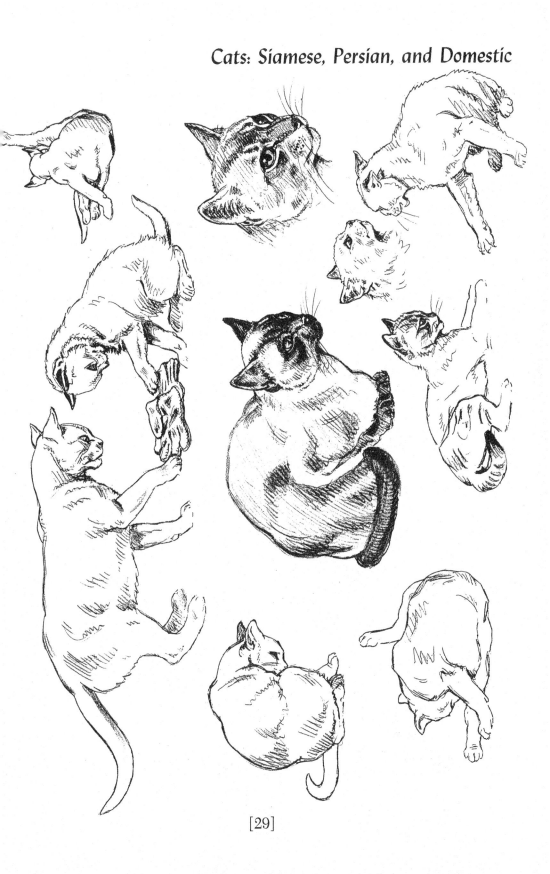

Goats, Ram, and Cattle

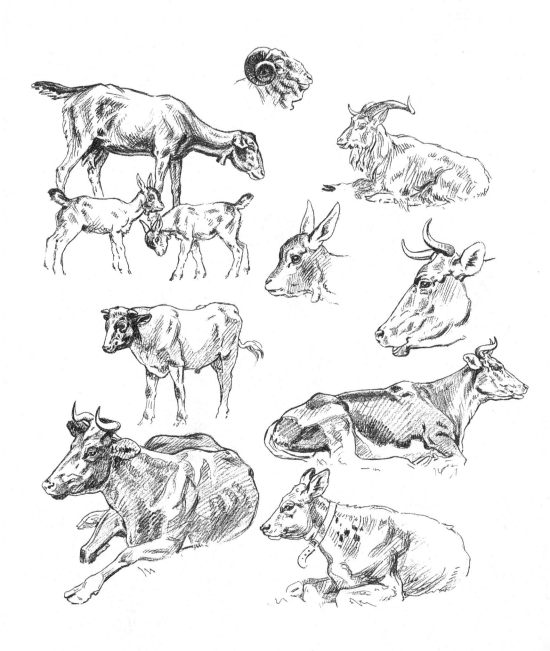

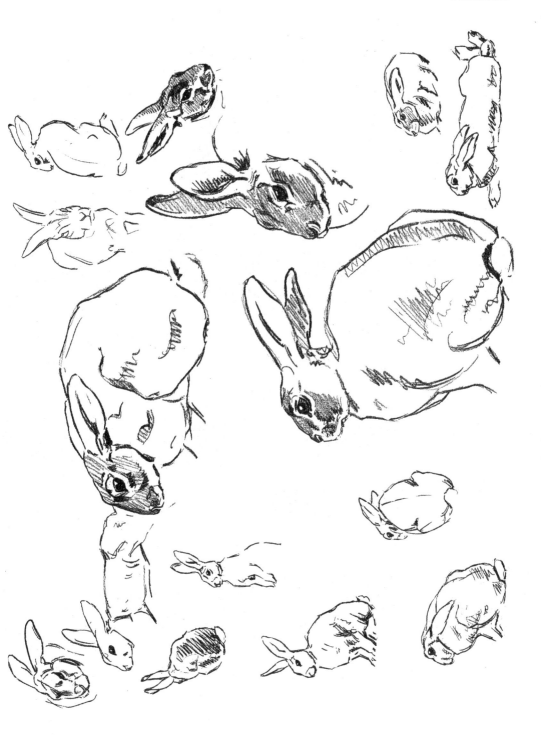

Foxes, Wolverine, and Opossum

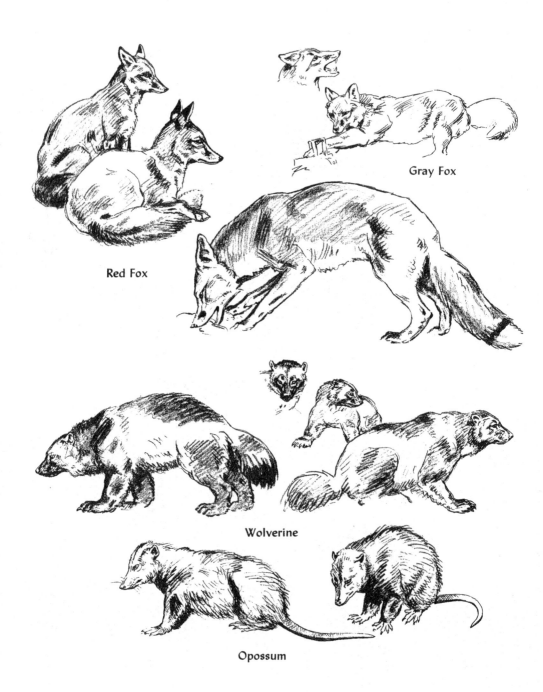

Gray Fox

Red Fox

Wolverine

Opossum

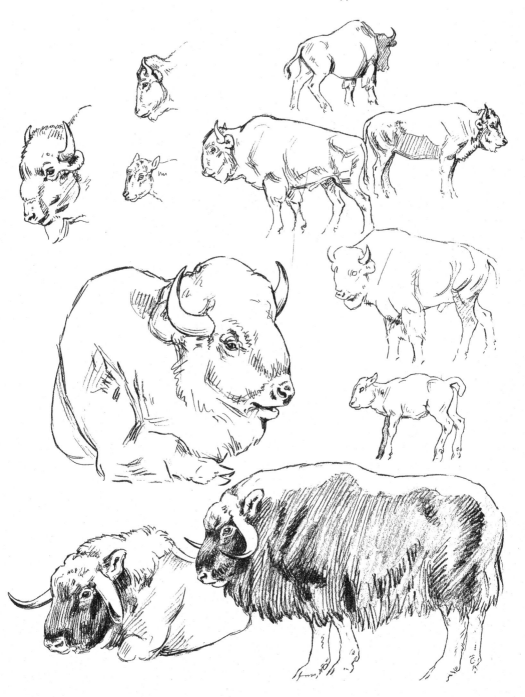

Mule Deer and Bull Moose

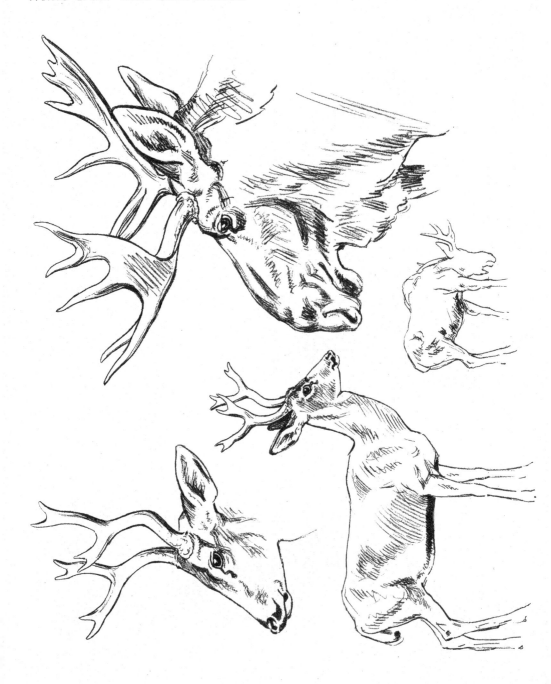

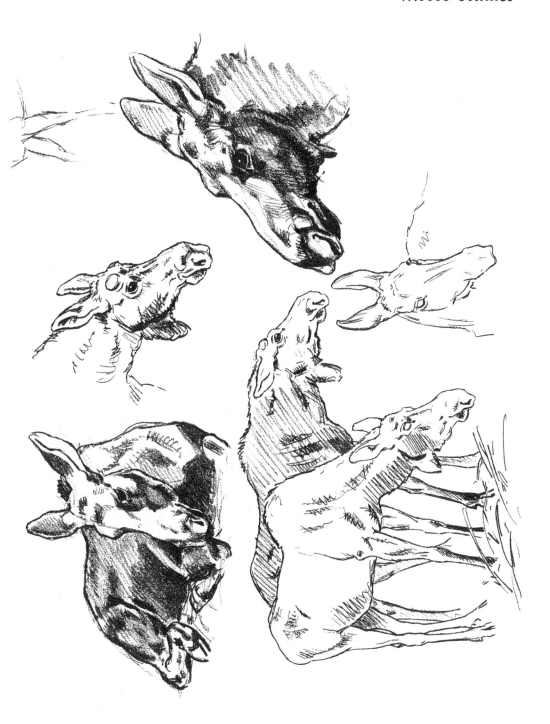

Cow Moose

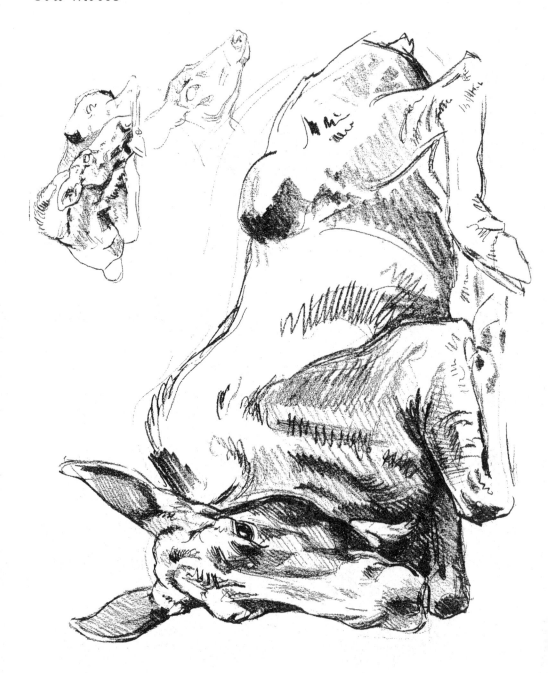

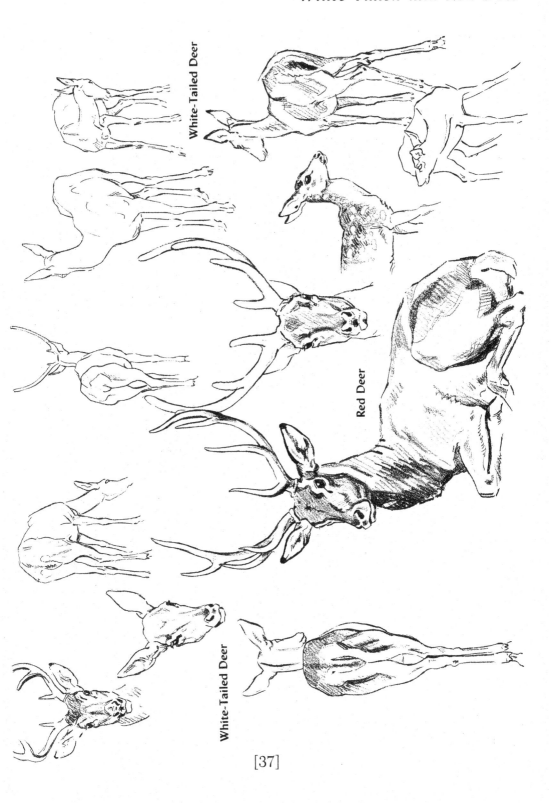

White-Tailed Deer

Red Deer

White-Tailed Deer

Elk

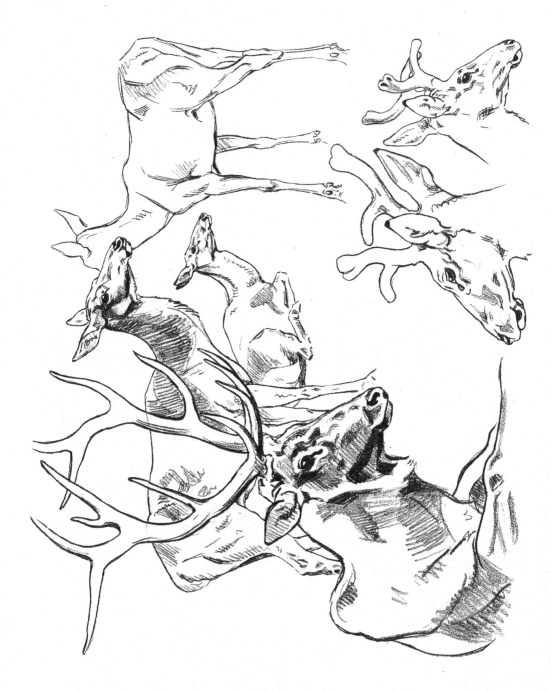

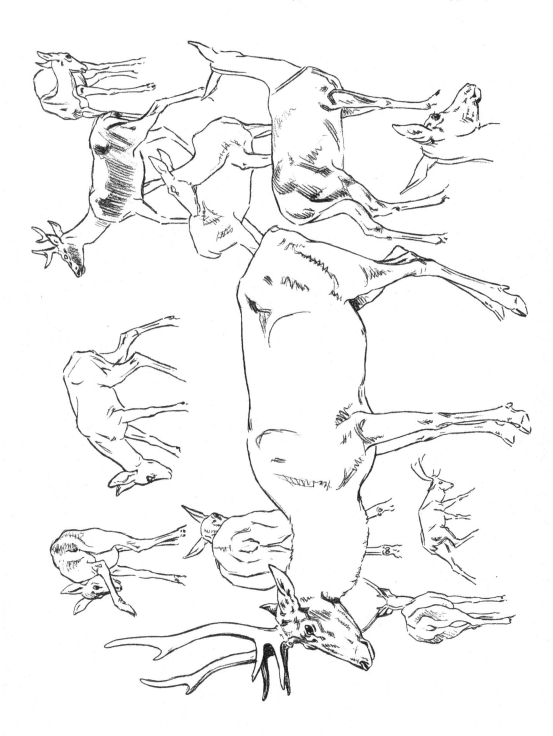

Mountain Sheep (Rams)

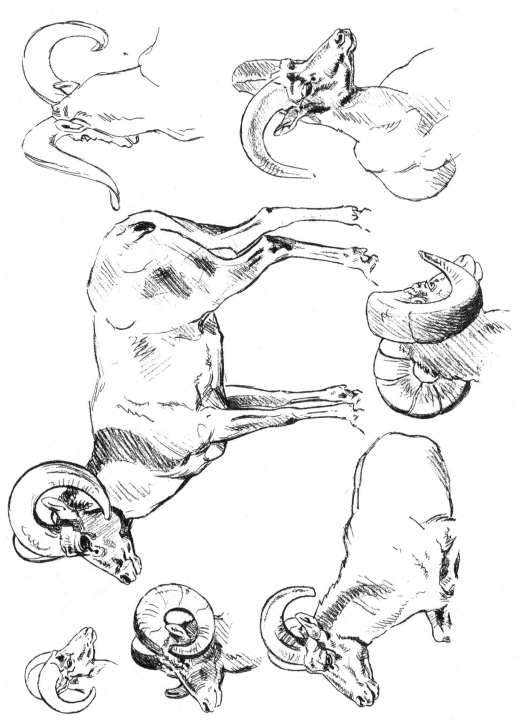

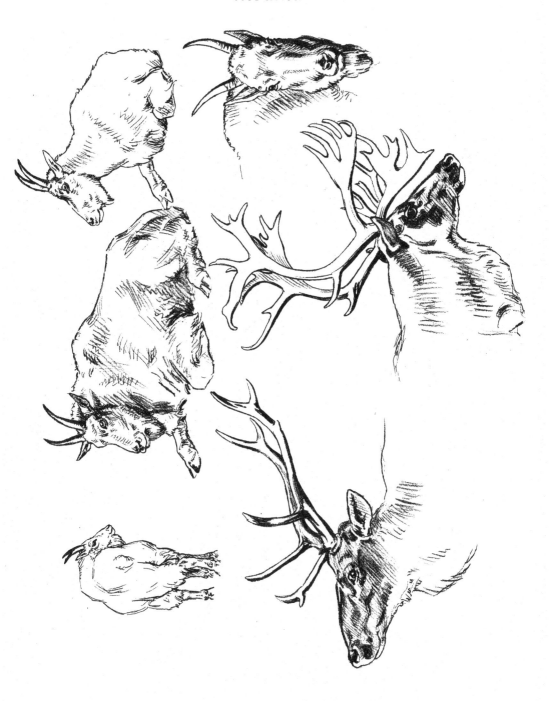

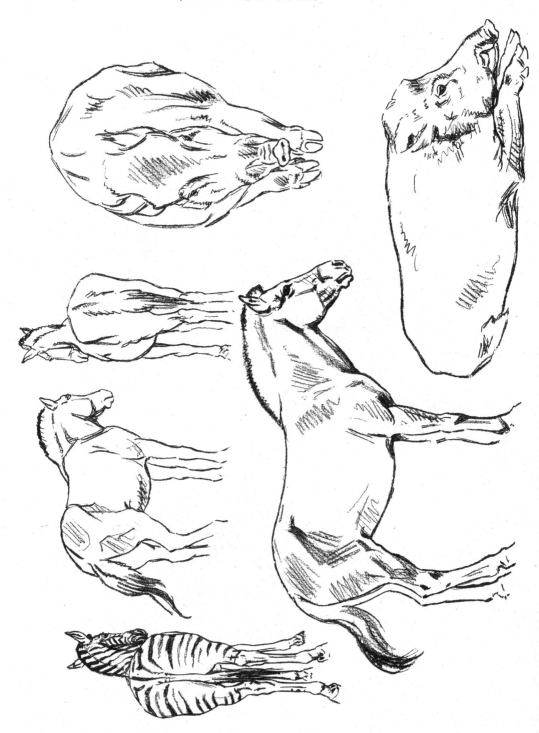

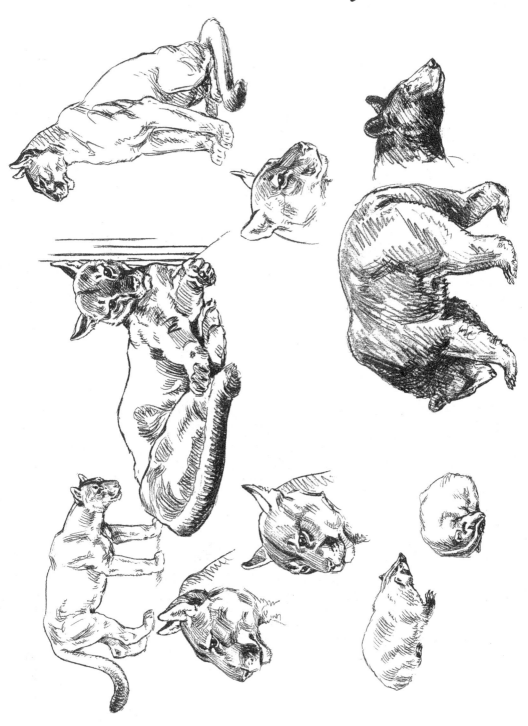

Wolf and Coyote

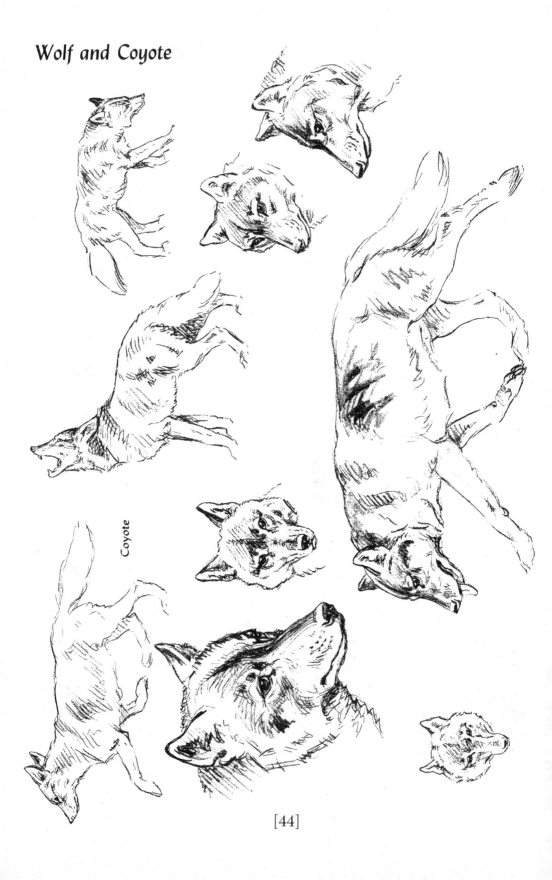

Coyote

Moose

Peccary

Buffalo Calf

Elk

White-Tailed Deer

Pronghorn Antelope

Young Animals

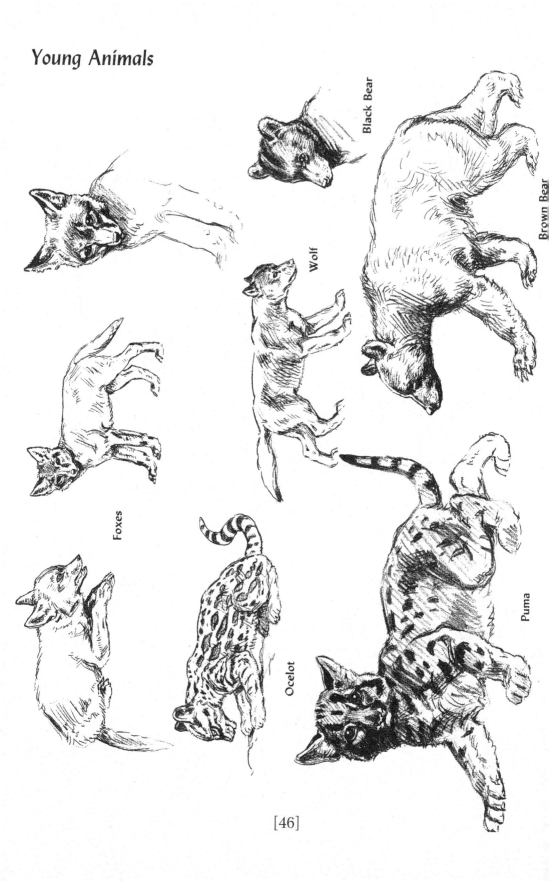

Black Bear

Brown Bear

Wolf

Foxes

Ocelot

Puma

[46]

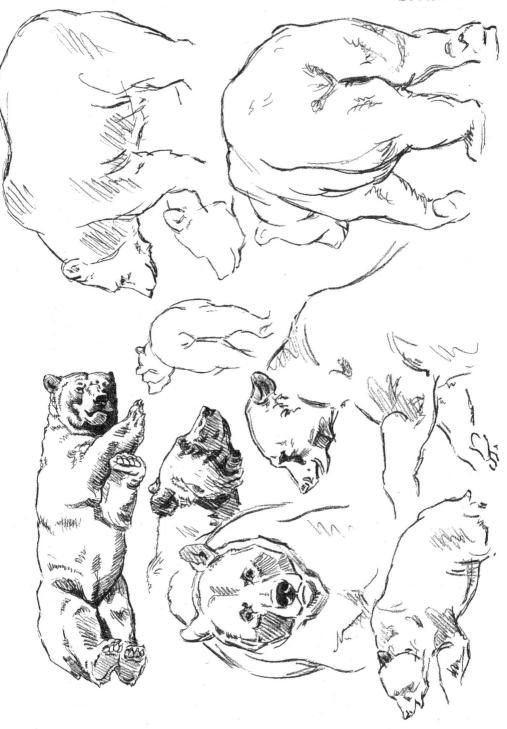

Lions

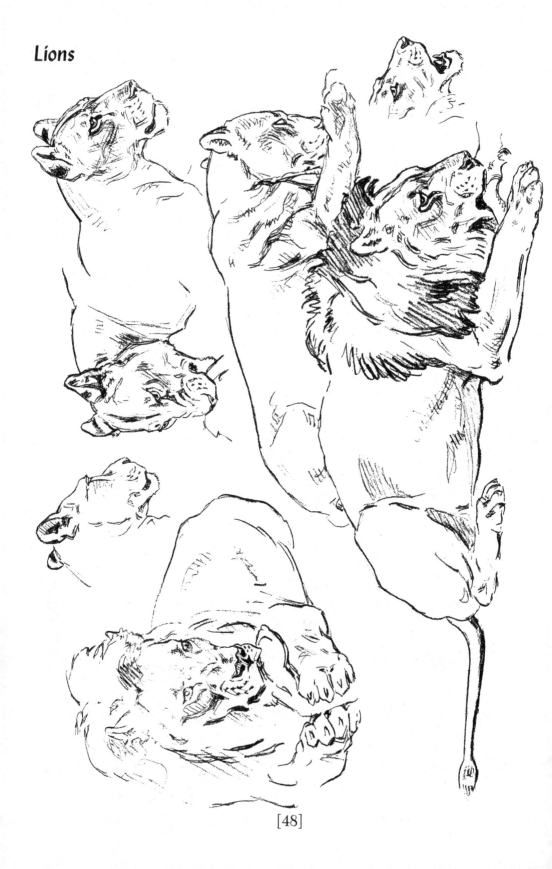

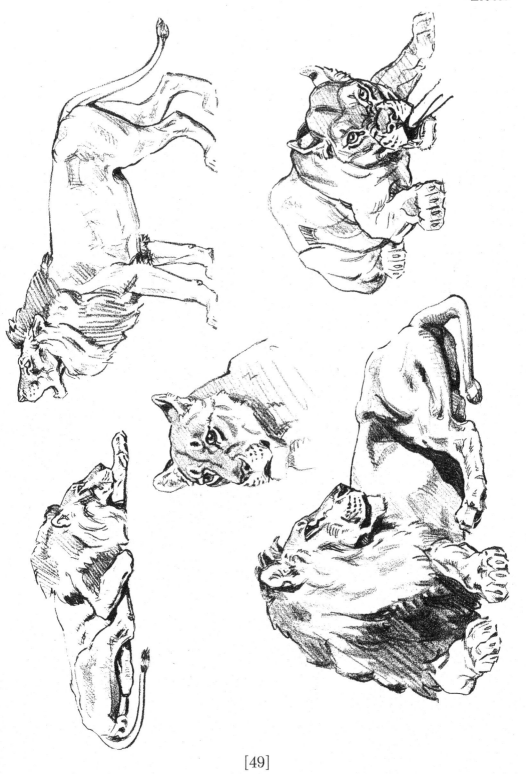

Polar Bear, Wolf, and Hyena

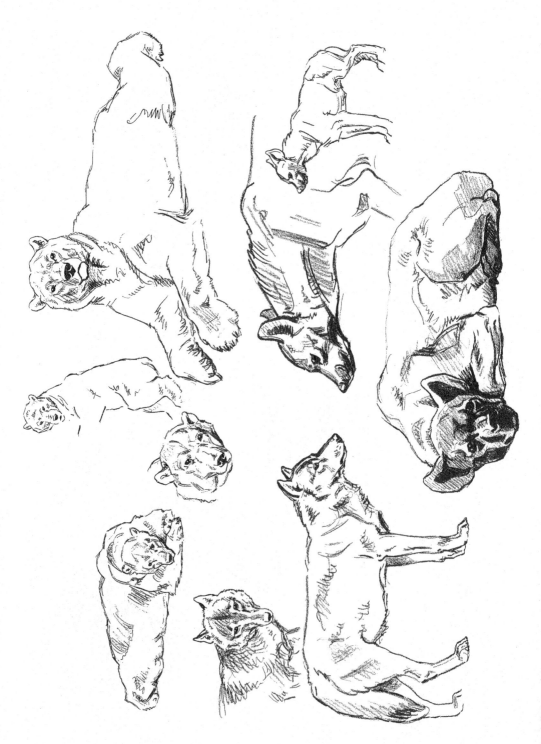

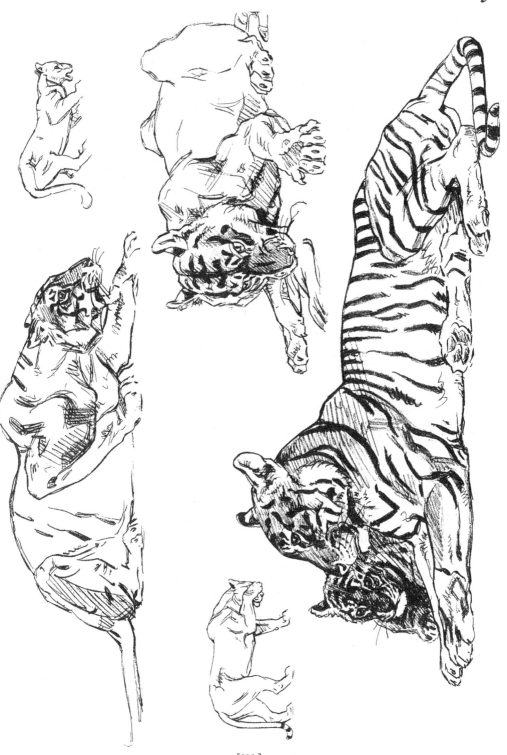

Color Sketching

It may be practical for quick color sketching to use loose-leaf paper so that sheets can be easily substituted when the models force us to start new sketches. A heavy paper will not curl or bend as much under the brushstrokes as a thinner grade. Taking less time to dry, it will also not delay your work as much as the thinner sheet. Start your sketch with light, pencil lines, drawing only the most necessary and important features. Do several different poses on the same page; then if the animal moves, you will be able to work on whatever pose he assumes (left, right, side, front, back views, etc.).

A light portable chair and a suitcase on which you can place your water jar and colors will save a lot of uncomfortable bending to reach for your colors. Take along an extra bottle of water; many times there will be no supply nearby and your water will get so dirty that it will influence the more brilliant colors.

Water colors become paler when they dry. So don't be afraid to use a trifle stronger color than the final result you want. Always try to work in as comfortable circumstances as possible so that you can concentrate completely on your observation and sketching.

In working with oils you are limited to the number of wet sketches that can be stored in the paint box without smearing when you take them home. It also takes longer to mix the oil colors.

The beautiful color variations even in the least colorful animals are remarkable. The light and dark shades of the same color and the entire color scheme in beautiful harmony must thrill any painter. Many birds and tropical fish present color schemes and patterns which fantasy and imagination cannot equal.

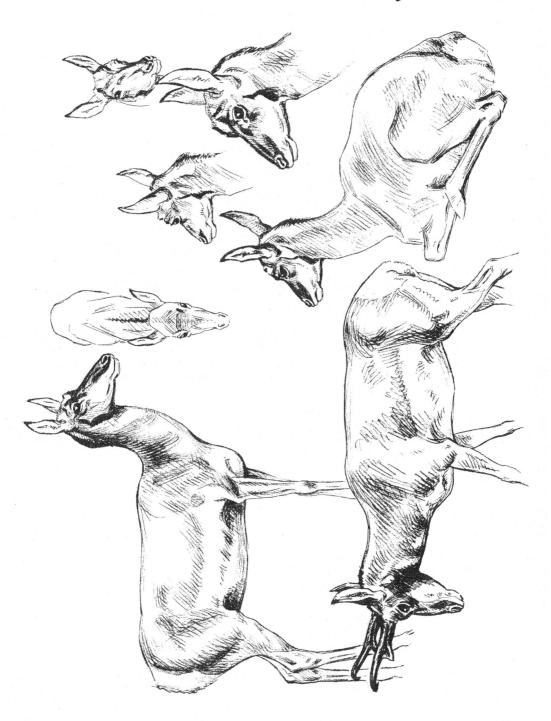

Animals in Motion

The most difficult and fascinating problem in animal sketching is to capture quick motion. Although moving picture camera series are a great help in eliminating major errors, the artist can draw animals in motion by observation alone.

Here, too, you should start systematically, first tackling the easiest motions, such as slow walking or grazing. Observe the relation of all four feet to each other and the way the head, neck, and body are carried. These are the essentials you must master in order to reduce misrepresentations to the minimum. When you try to catch the quicker motions by observing, you can probably get only a small part of the action, but when you put together the parts, you will complete the fast motion — trotting, galloping, or flying. The naked eye often gets a different impression of fast-moving subjects than does the faster and more precise camera. For instance, fast wing strokes cannot be seen all the way through, but only in the two extreme positions (highest and lowest). Between these will be a blur without detail. The camera will catch more detail, but the artist can, with long and close observation, achieve a more striking or beautiful effect.

Gallop (Pronghorn Antelope)

Leap (Lioness)

Rising (Mallard)

Descending (Mallard)

Game Birds in Full Flight

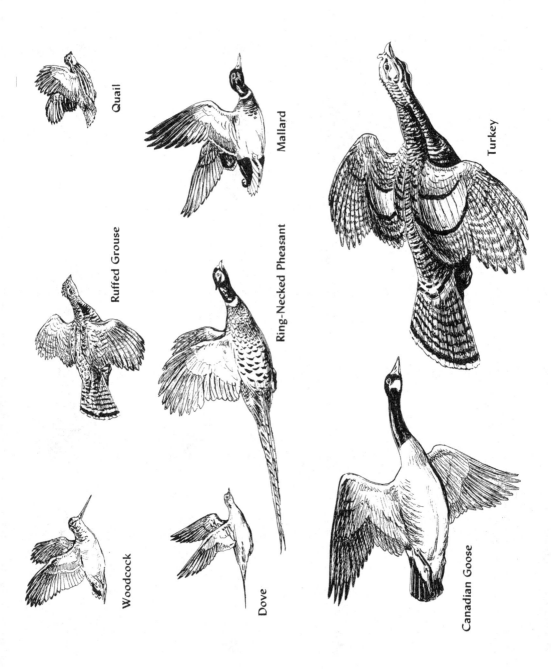

Quail

Mallard

Turkey

Ruffed Grouse

Ring-Necked Pheasant

Woodcock

Dove

Canadian Goose

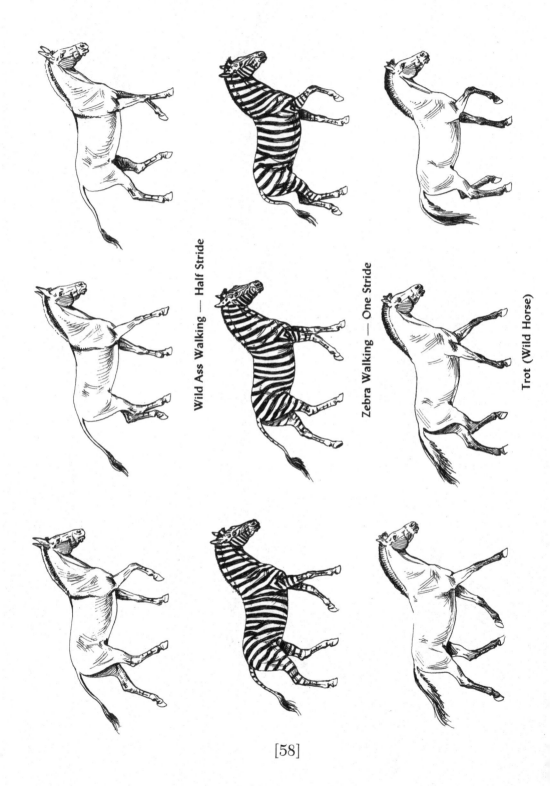

Wild Ass Walking — Half Stride

Zebra Walking — One Stride

Trot (Wild Horse)

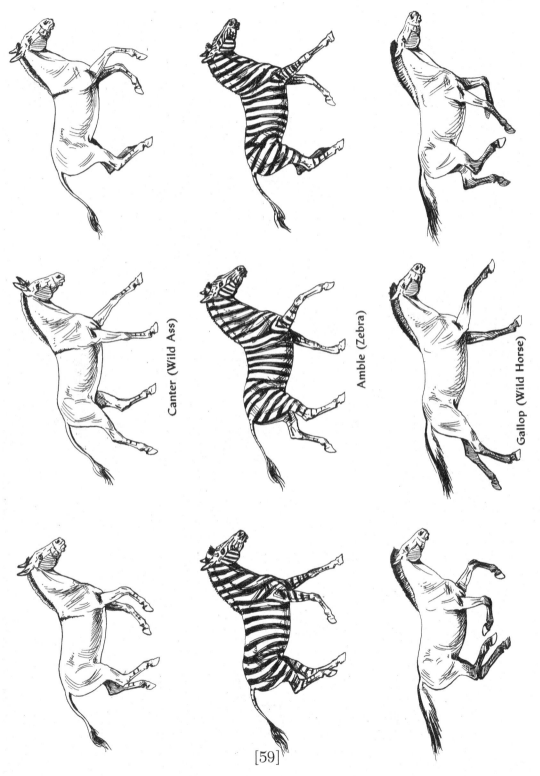

Canter (Wild Ass)

Amble (Zebra)

Gallop (Wild Horse)

Jumping Wild Horse

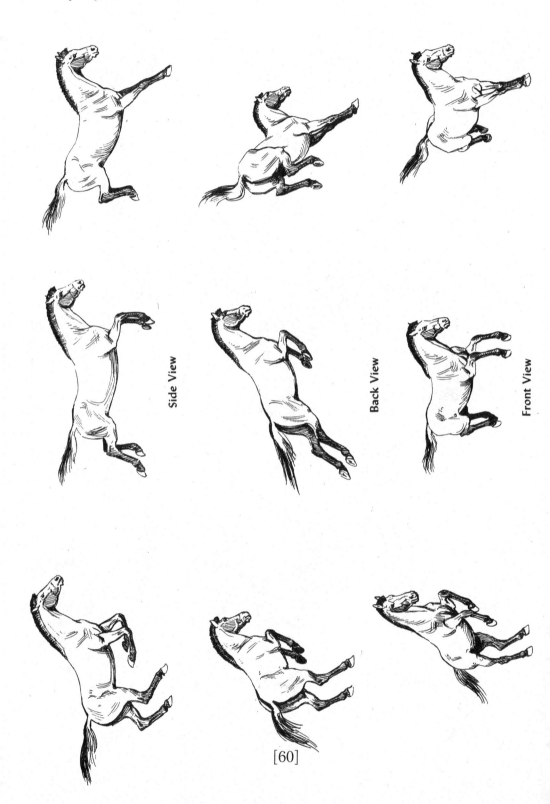

Side View

Back View

Front View

Common Gaits of Big Game Animals

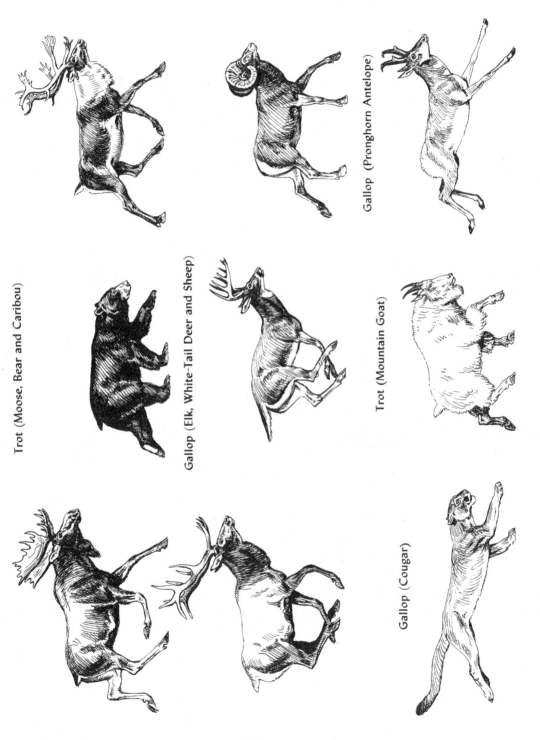

Trot (Moose, Bear and Caribou)

Gallop (Elk, White-Tail Deer and Sheep)

Gallop (Pronghorn Antelope)

Trot (Mountain Goat)

Gallop (Cougar)

Game Fish: Salmon and Bass

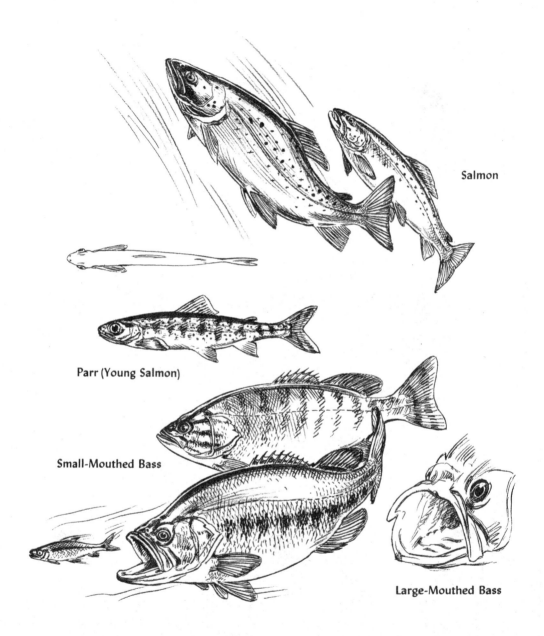

Salmon

Parr (Young Salmon)

Small-Mouthed Bass

Large-Mouthed Bass

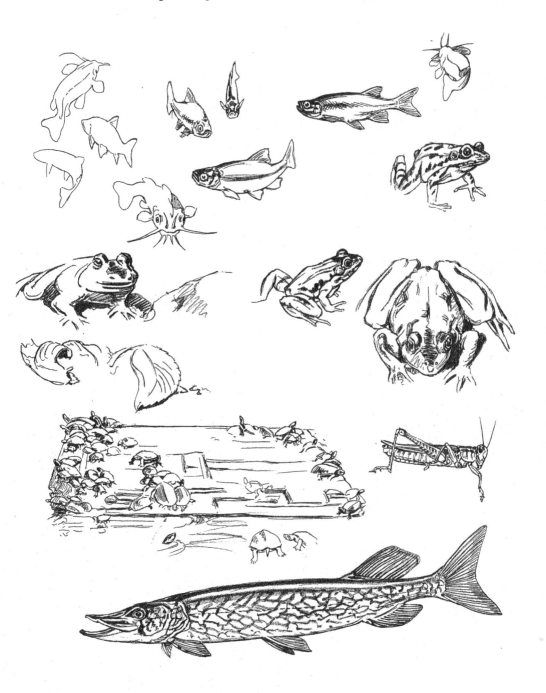